Shutters Up

A Collection of Travel and Bird Photographs

by

Vidhya Narayanan

ISBN : 1470108275
ISBN-13: 978-1470108274

*Dedicated to my husband,
for his unwavering support and motivation.*

Foreword

The world that rotates around us carries with it such instances that happen in a span of a few seconds, but come with a flavor that lingers in your mind forever. Snapshots of life, wildlife and the world around that either puts that little smile on the edge of your lips or makes you sit back and introspect. And there is a joy remnant in those moments when you see them through the eyes of the lens.

Shutters Up is a collection of my select Bird and Travel Photographs. The first half of this collection is Bird photographs comprising several species of birds ranging from those commonly seen in backyards to those that migrate thousands of miles to visit us from as far as the Arctic belt. All the birds are photographed in their natural environment. The second half of the collection covers, among others, unique views of the famous Taj Mahal and the lesser known Lotus Temple in India to an exotic view of the Empire State Building and the snowy beauty of Central Park, New York.

Photographs render a visceral inspiration, far intuitive than one could ever imagine. I believe this collection would be another step in appreciating the natural and manmade beauty around us and perhaps motivate you to visit some of these places to experience the joy of their magnificence.

BIRDS

INDIAN PEACOCK

Suburbs of Hyderabad, India.

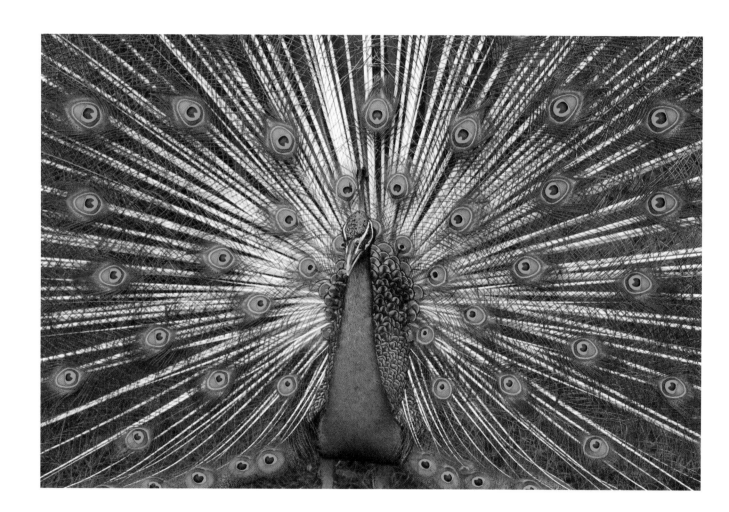

BLACK SKIMMER

BRIGANTINE, NEW JERSEY.

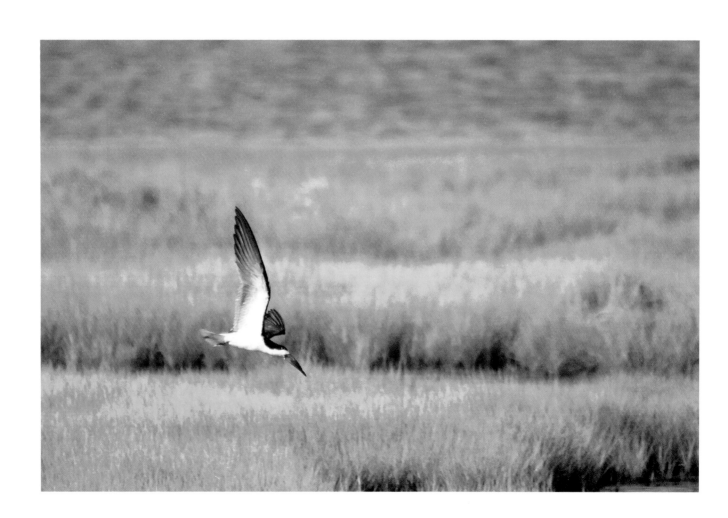

GREEN BEE-EATER

SUBURBS OF HYDERABAD, INDIA.

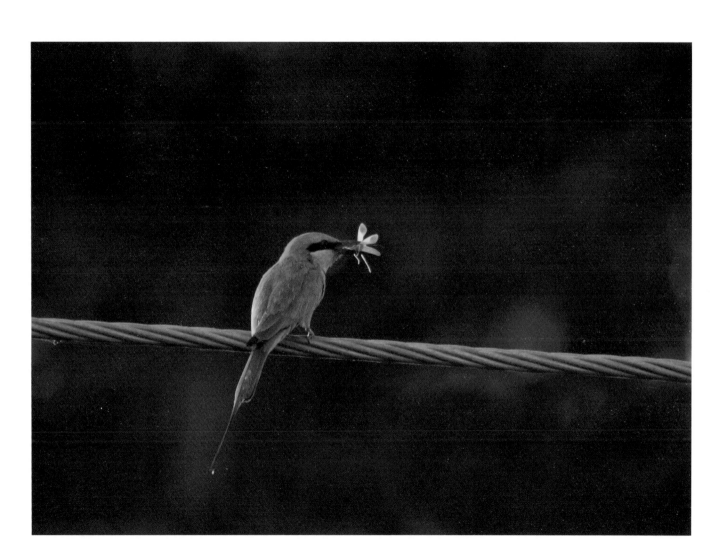

INDIAN COOT ON THE MORNING WATERS

SANJEEVAIAH PARK, HYDERABAD, INDIA.

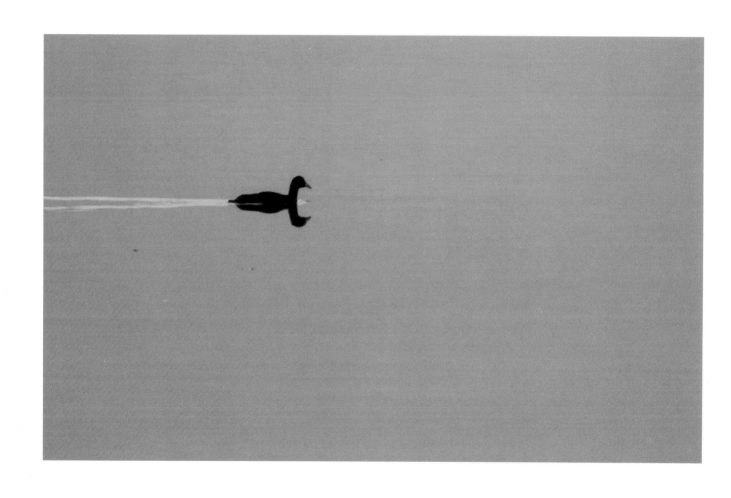

TURTLE DOVE

HYDERABAD, INDIA.

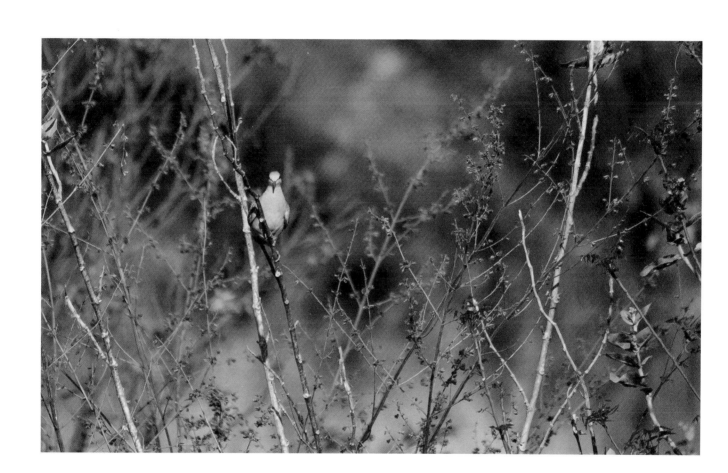

PURPLE-RUMPED SUNBIRD

HYDERABAD, INDIA.

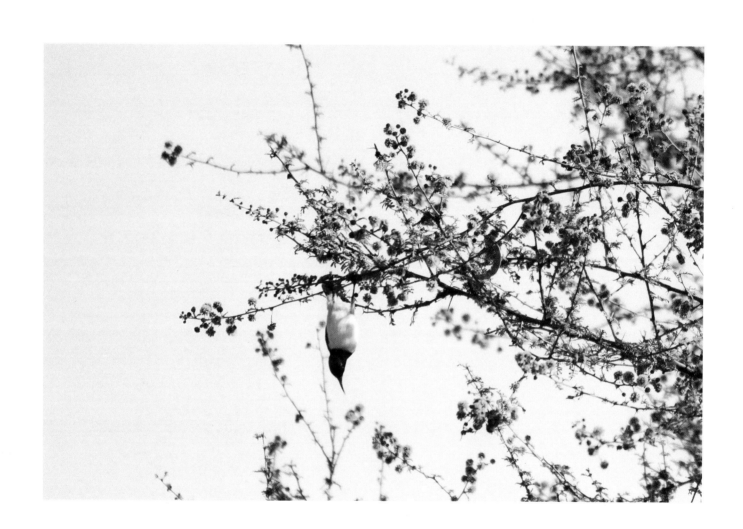

BROWN PELICAN TAKE-OFF

MUSTANG ISLAND, TEXAS.

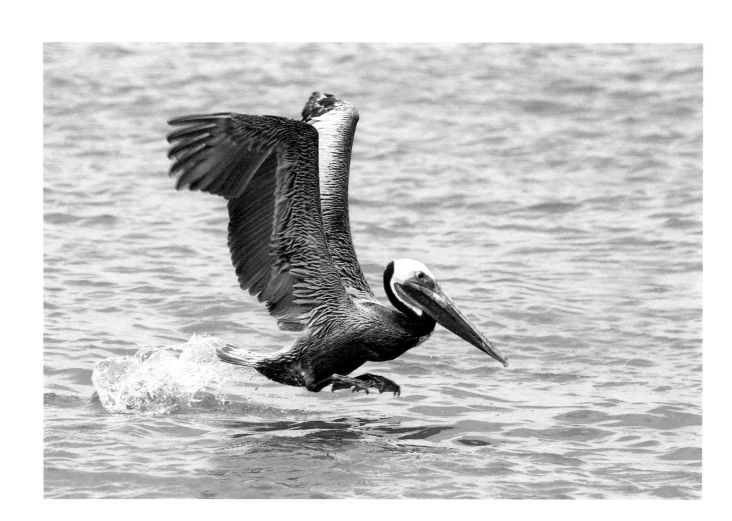

ATLANTIC BRANT

HUDSON RIVER, JERSEY CITY COAST, NEW JERSEY.

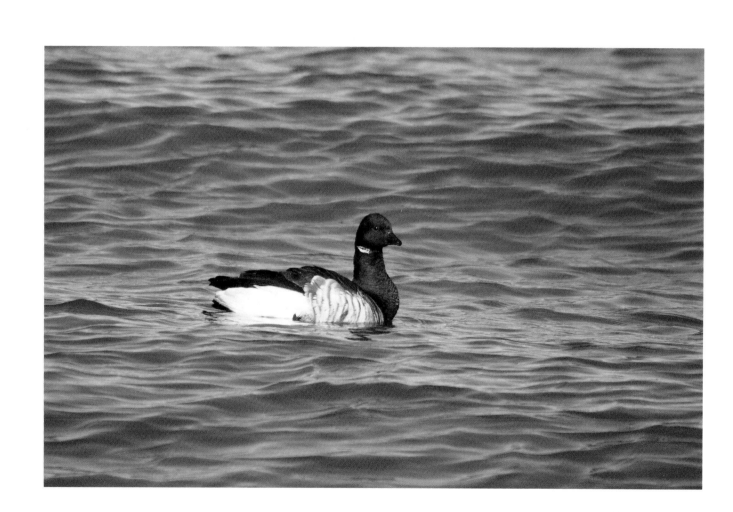

AMERICAN OYSTERCATCHERS

JAMAICA BAY WILDLIFE REFUGE, NEW YORK.

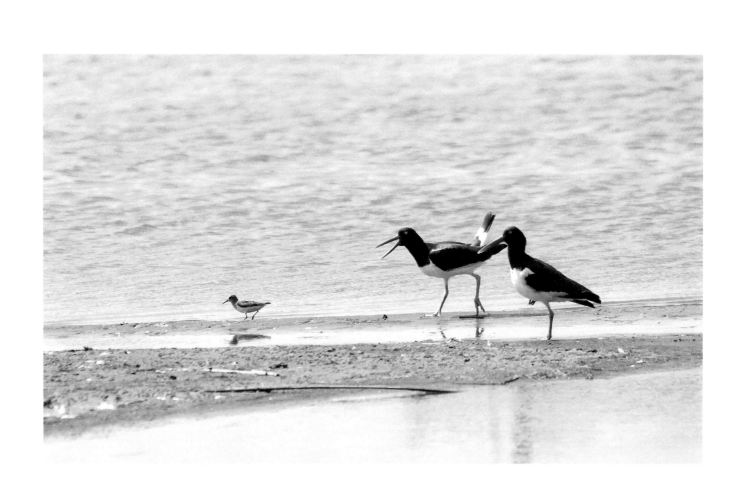

TREE SWALLOW

JAMAICA BAY WILDLIFE REFUGE, NEW YORK.

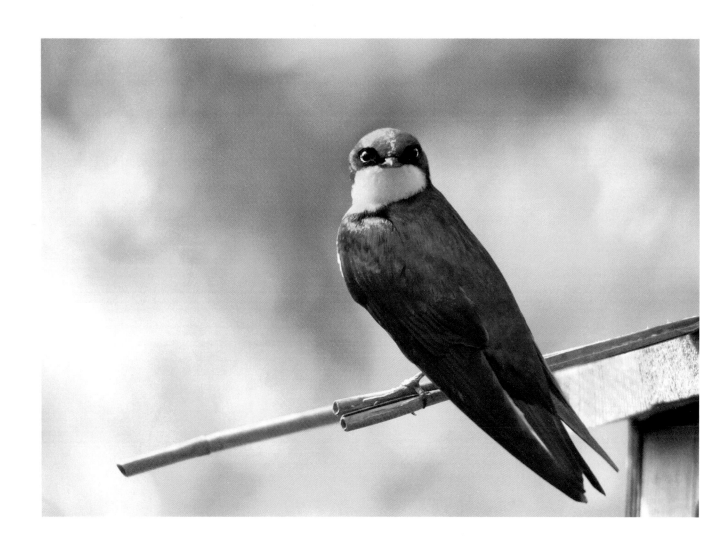

TUNDRA SWANS IN FLIGHT

BRIGANTINE, NEW JERSEY.

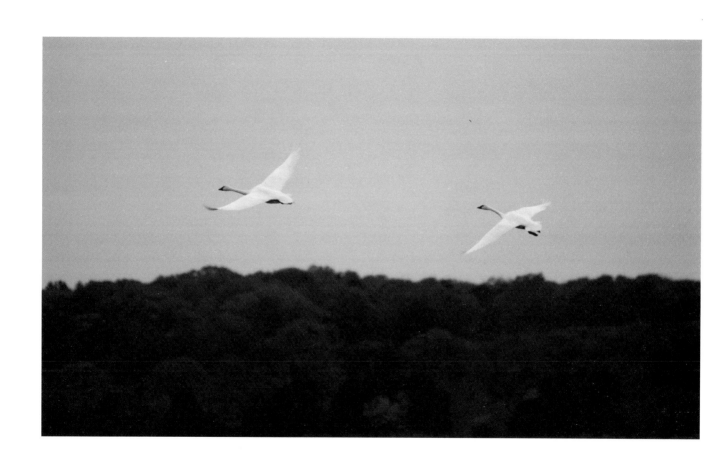

HERRING GULL

BELLMORE, NEW YORK.

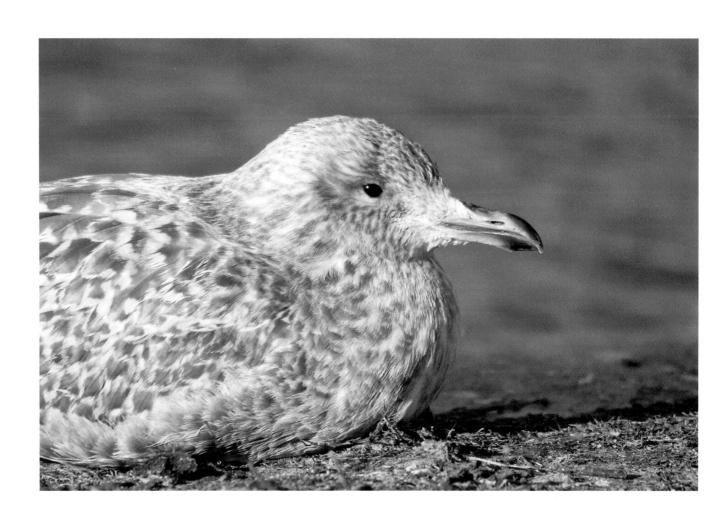

GREAT BLUE HERON

MUSTANG ISLAND, TEXAS.

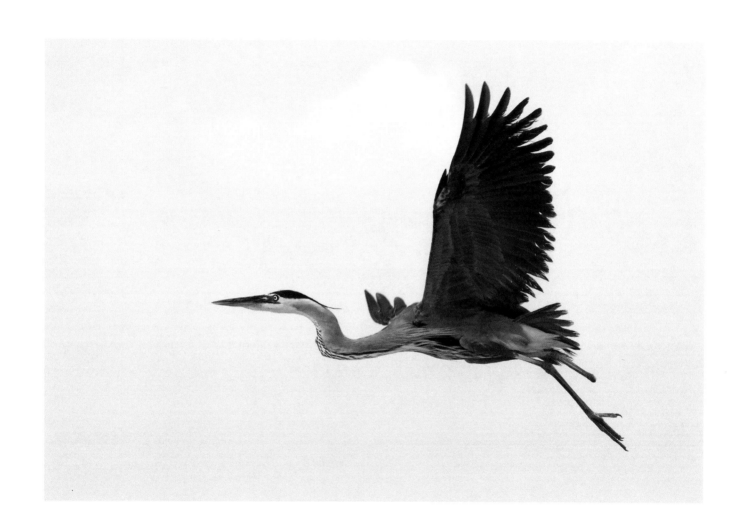

Rufous Hummingbird

Outside American Museum Of Natural History, New York.

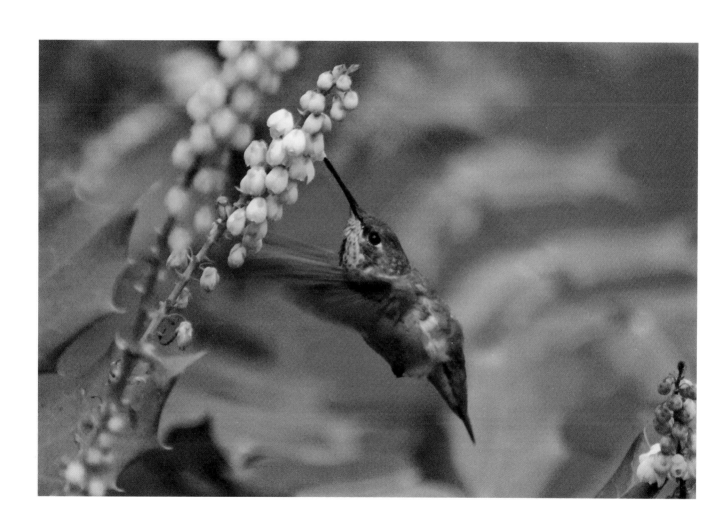

HOODED MERGANSER

CENTRAL PARK, NEW YORK.

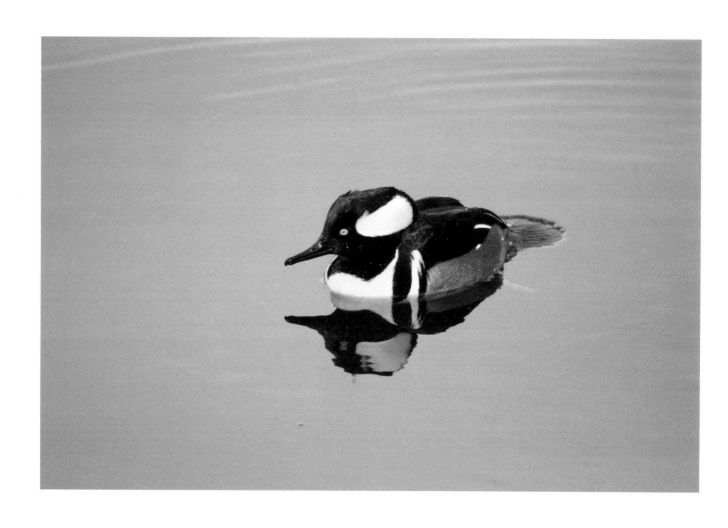

AMERICAN COOT COURTSHIP

CENTRAL PARK, NEW YORK.

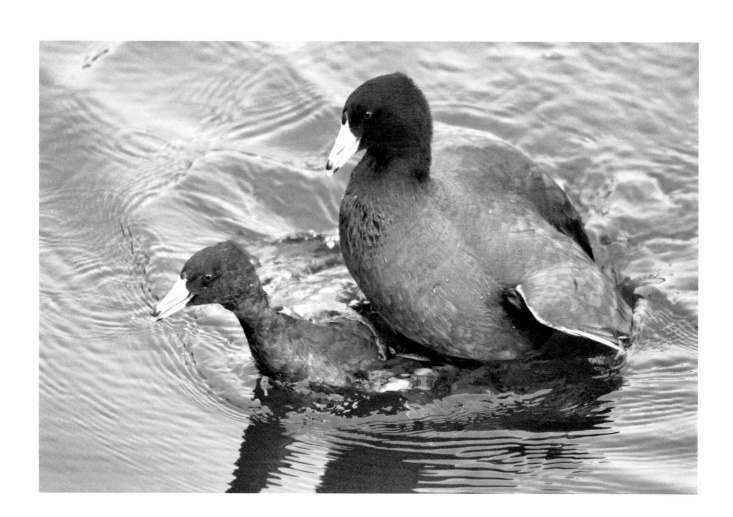

PURPLE SANDPIPER

BARNEGAT, NEW JERSEY.

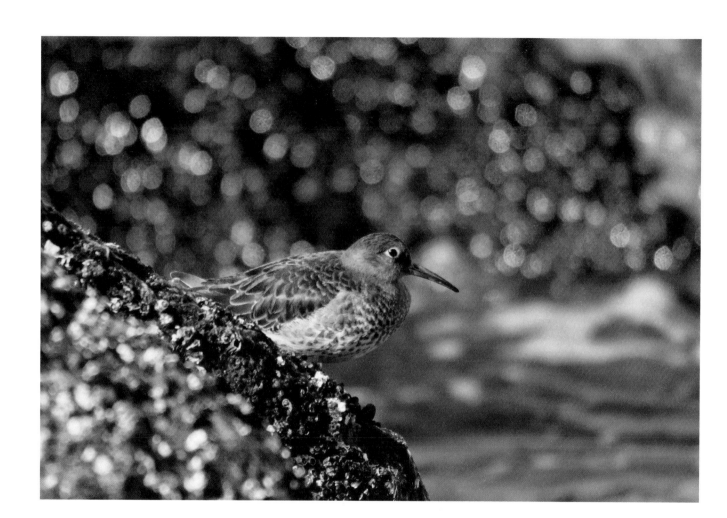

LONG-TAILED DUCK

BARNEGAT JETTY, NEW JERSEY.

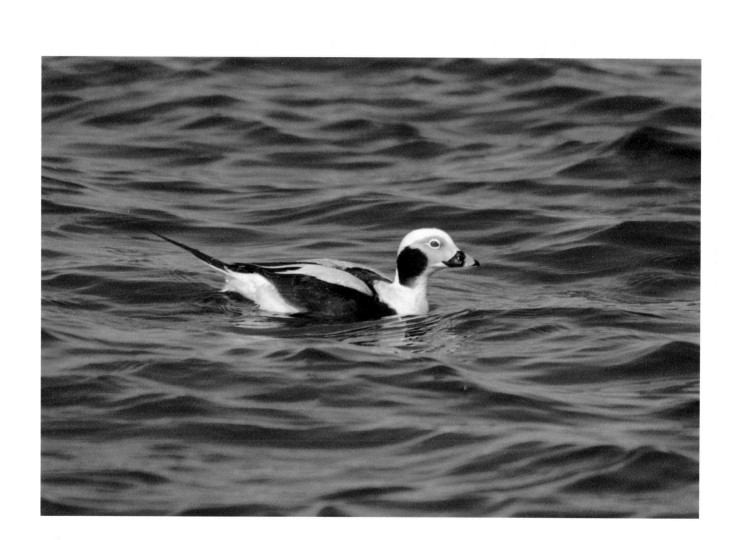

Northern Cardinal Courtship

Central Park, New York.

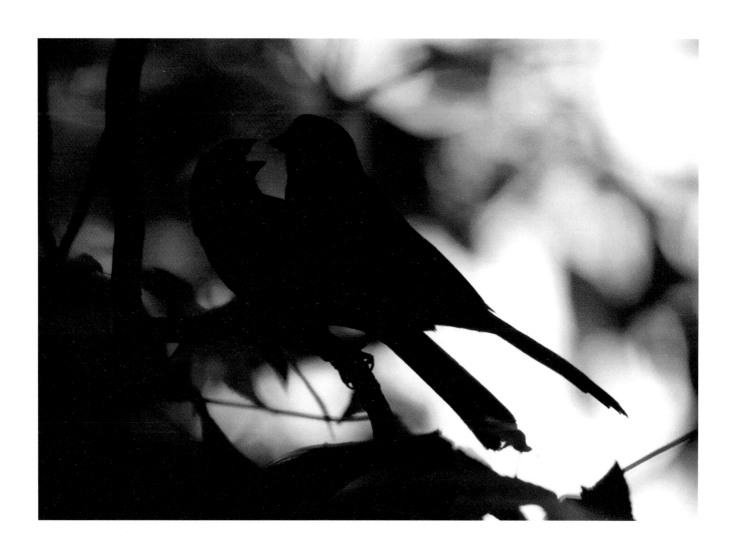

HARLEQUIN DUCK

BARNEGAT, NEW JERSEY.

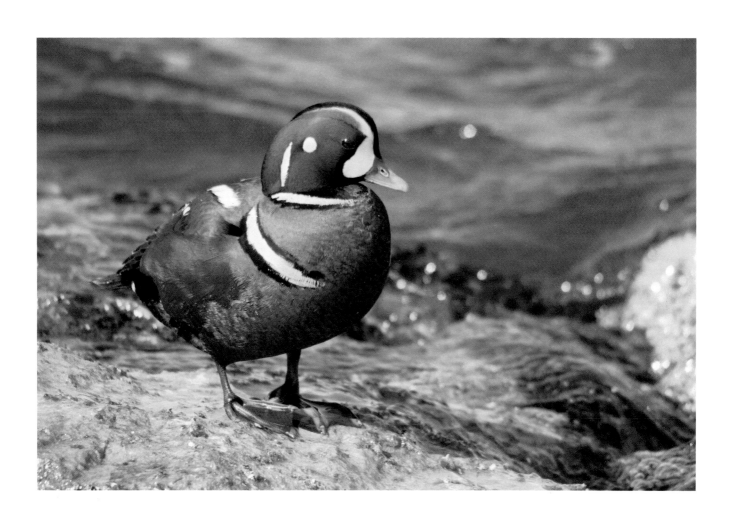

RED TAILED HAWK

CENTRAL PARK, NEW YORK.

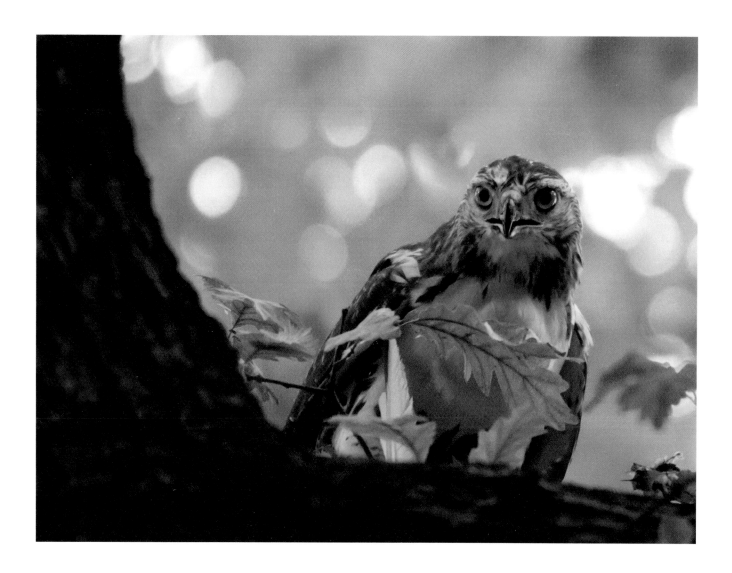

Ovenbird

Bryant Park, New York.

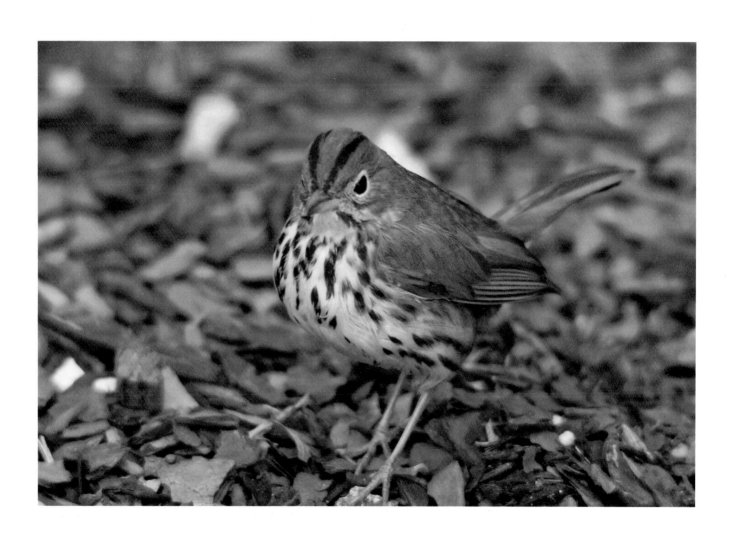

Black-Bellied Plover

Jones Beach, New York.

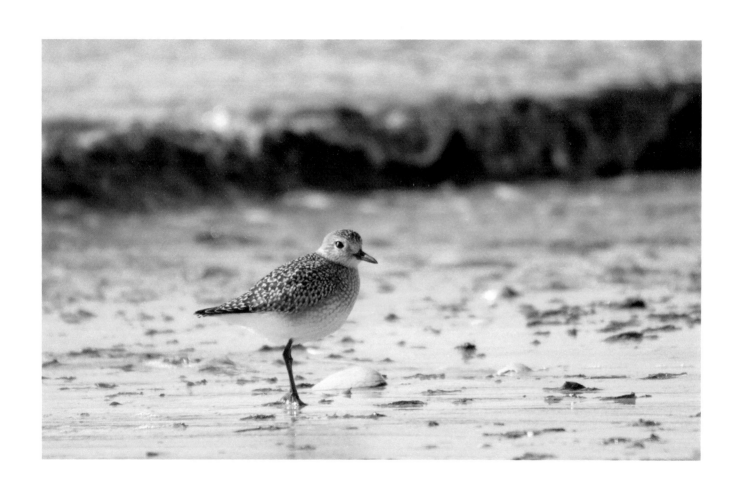

YELLOW-BREASTED CHAT

UNION SQUARE, NEW YORK.

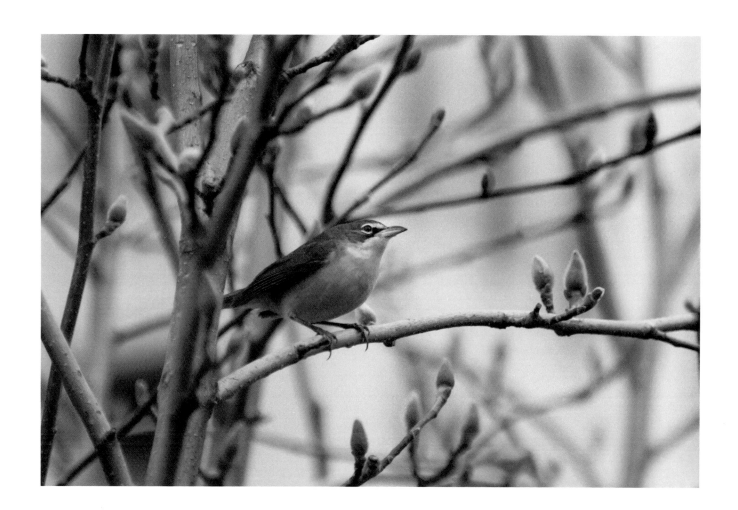

WHITE-BROWED WAGTAIL

SANJEEVAIAH PARK, HYDERABAD, INDIA.

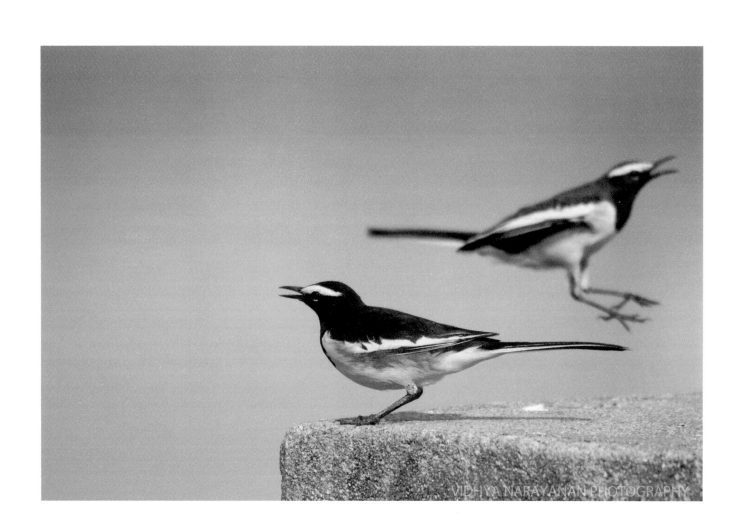

INTERMEDIATE EGRET

SANJEEVAIAH PARK, HYDERABAD, INDIA.

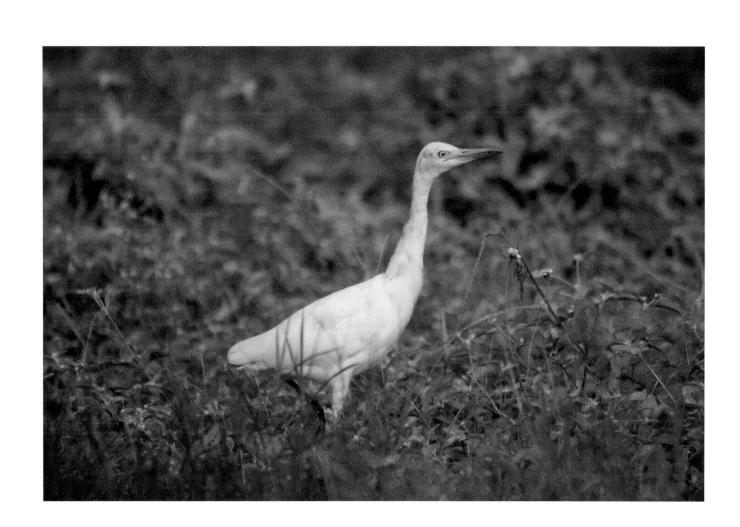

MUTE SWAN

JAMAICA BAY WILDLIFE REFUGE, NEW YORK.

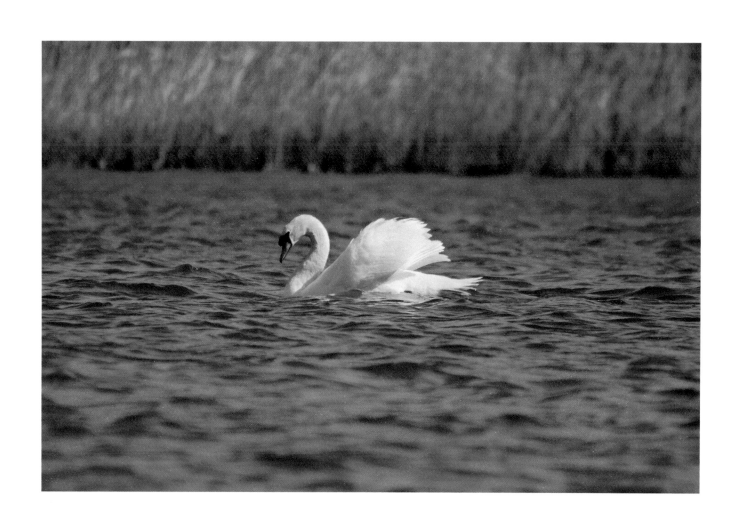

BLUE JAY

CENTRAL PARK, NEW YORK.

Yellow-bellied Sapsucker

Central Park Feeders, New York.

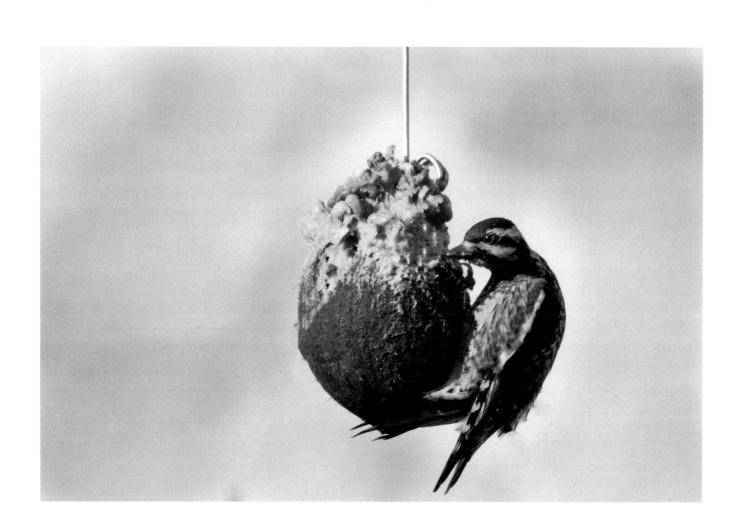

SNOW GEESE

JAMAICA BAY, NEW YORK.

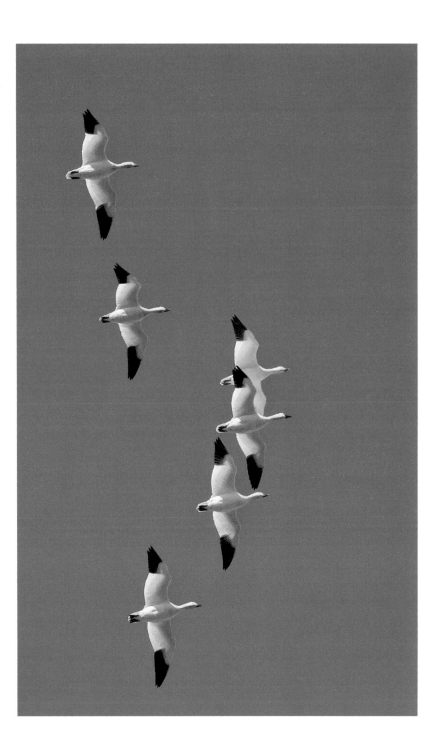

COOPER'S HAWK

PROSPECT PARK, NEW YORK.

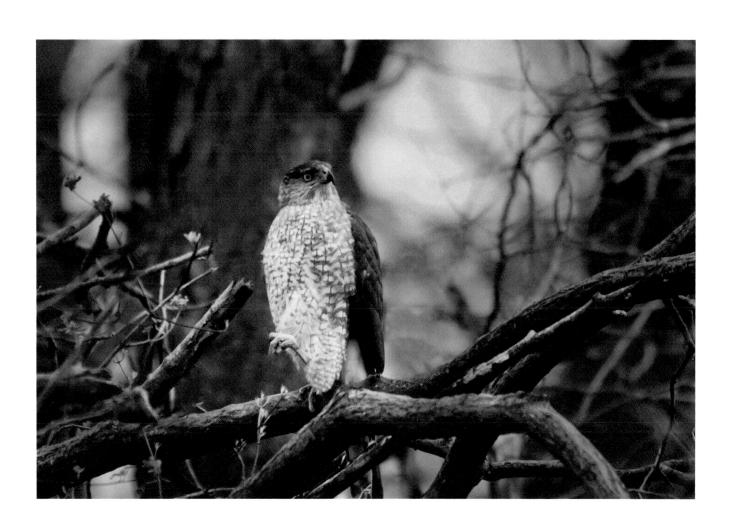

TRAVEL

The Brooklyn Bridge at Twilight

Brooklyn Bridge Park, New York.

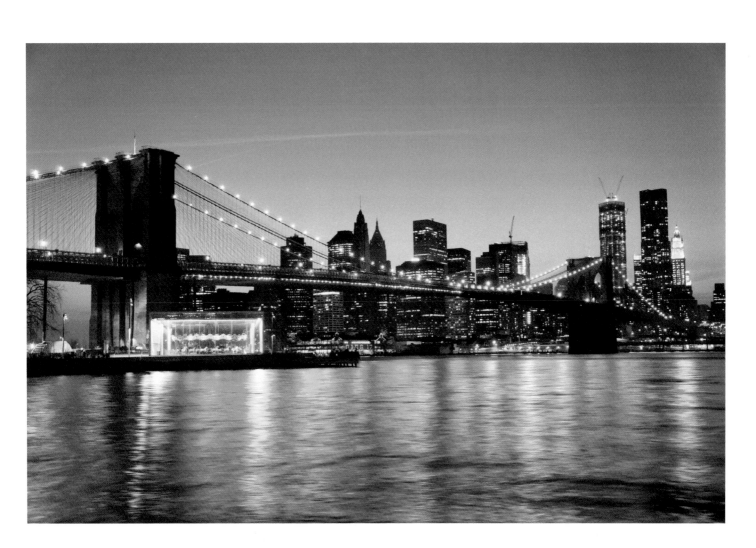

THE EMPIRE STATE BUILDING – SOARING INTO THE MID-DAY SKY

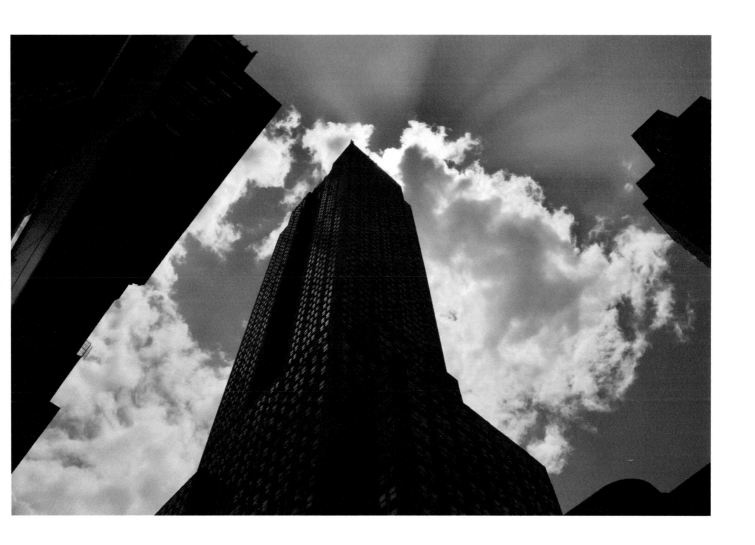

EN ROUTE BEAR MOUNTAIN STATE PARK

NEW YORK.

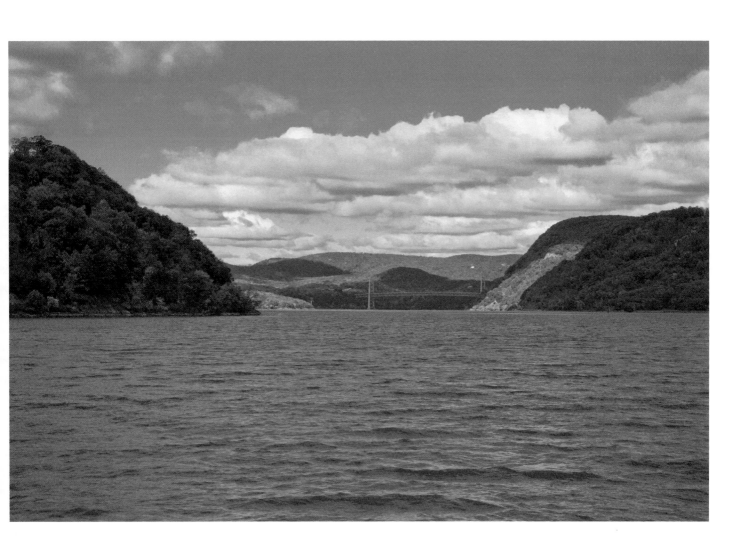

THE TAJ MAHAL

AGRA, INDIA.

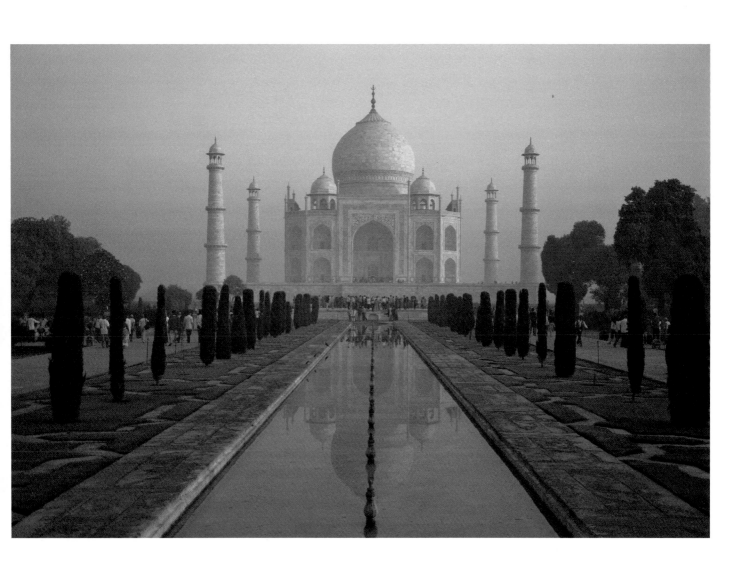

THE JOURNEY HOME

MUSTAND ISLAND, TEXAS.

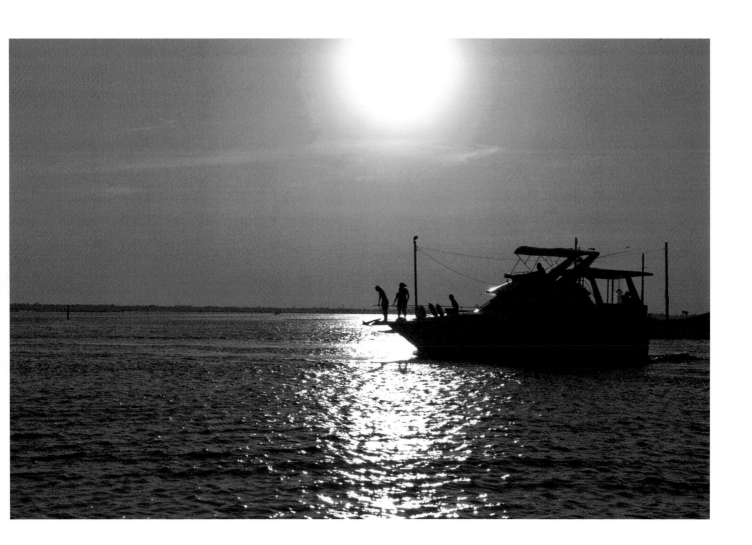

THE BROOKLYN BRIDGE

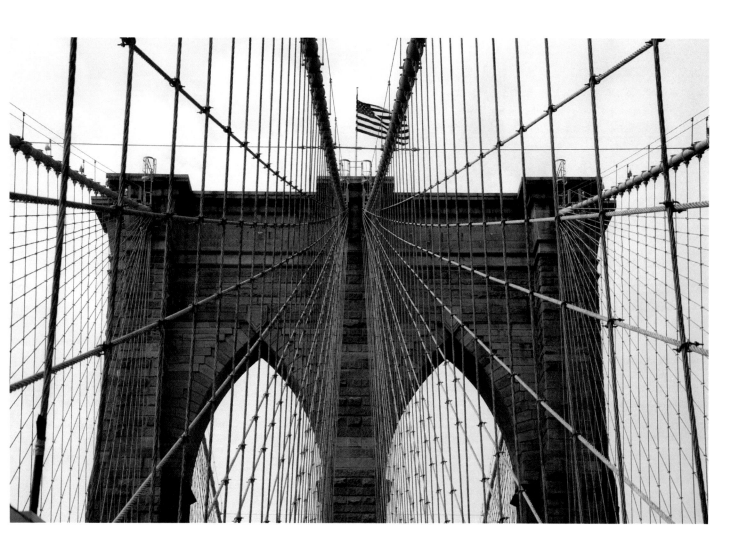

The Manhattan Bridge

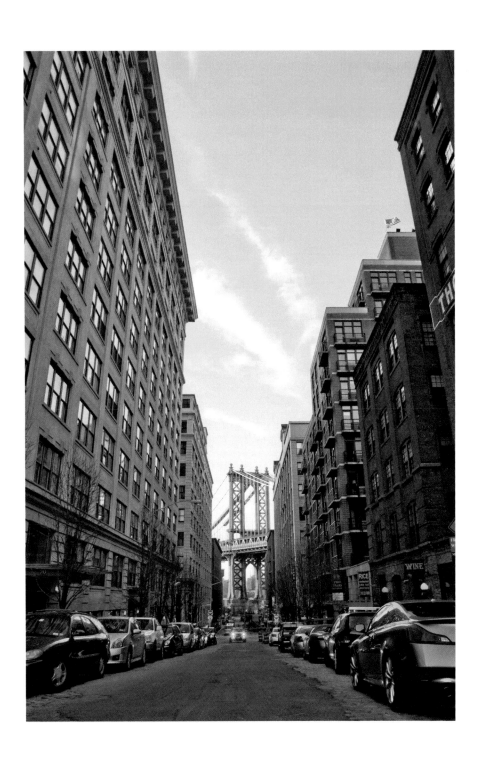

FALL IN CENTRAL PARK

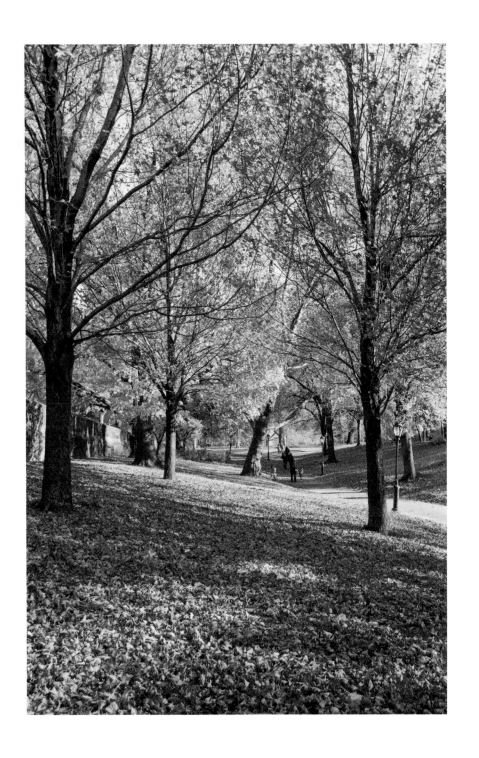

WINTER IN CENTRAL PARK

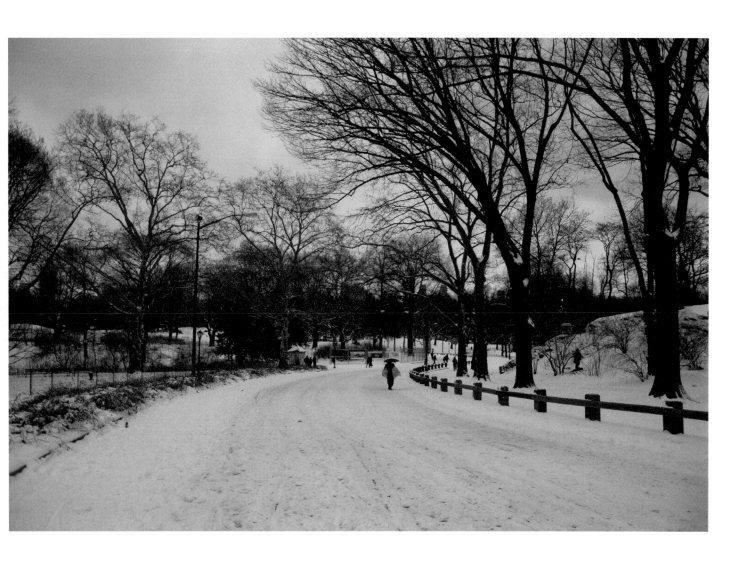

SNOW CLAD BENCHES AT CENTRAL PARK

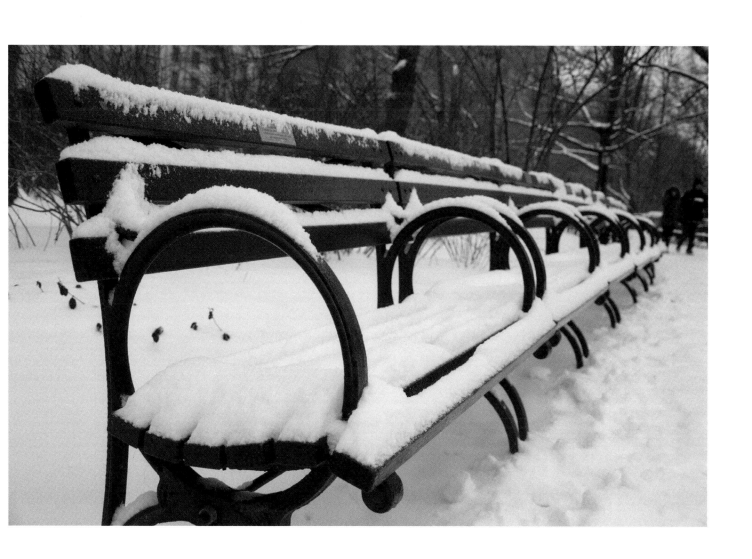

Taste Of Spring

Brooklyn, New York

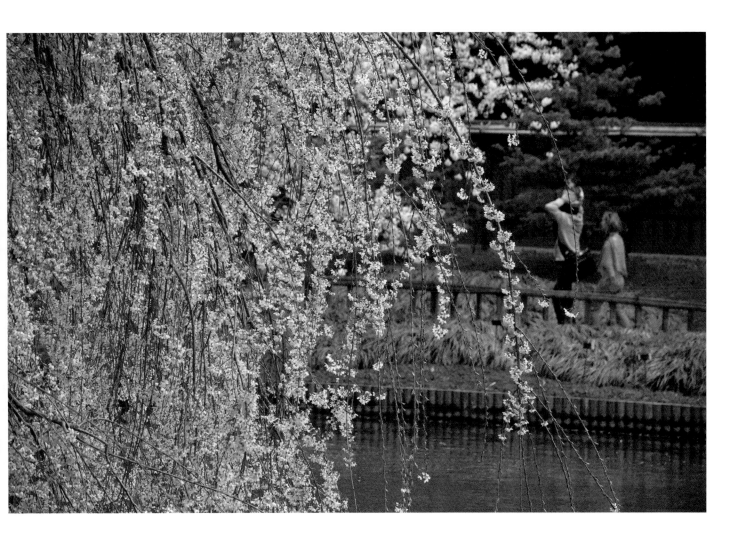

LAKE KANAWAUKE

HARRIMAN STATE PARK, NEW YORK.

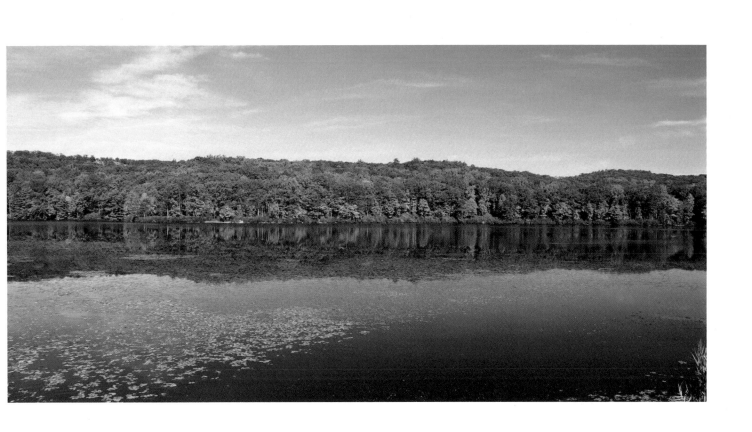

ROCKEFELLER CENTER CHRISTMAS TREE

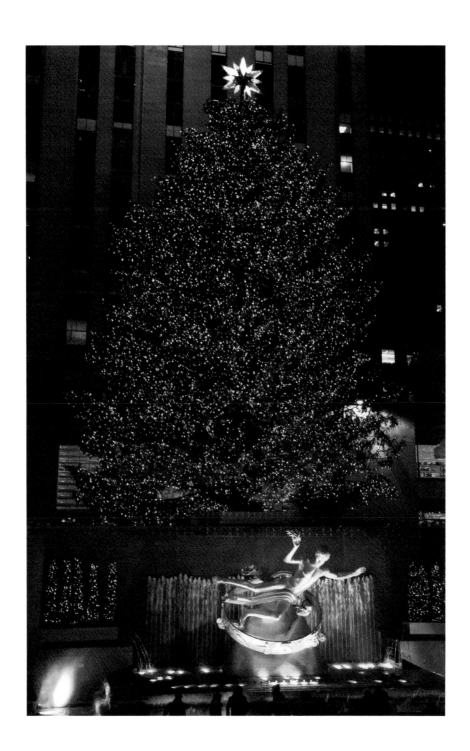

HOLIDAY LIGHTS AT THE WINTER GARDEN

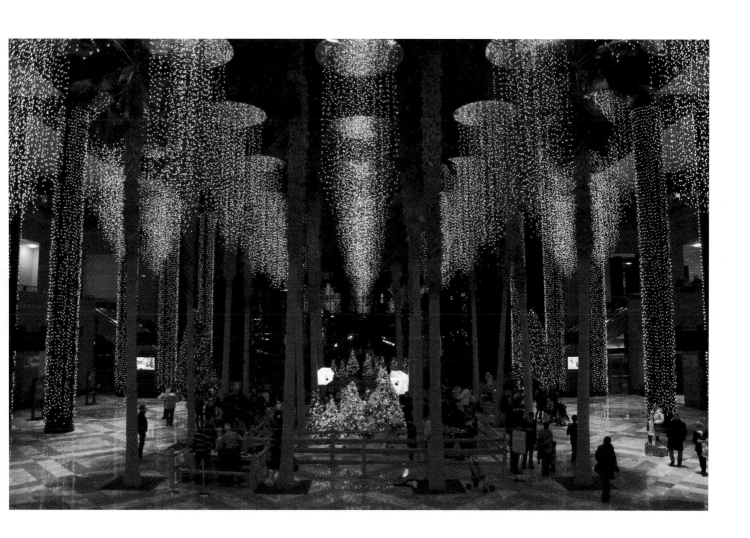

THE FOURTH OF JULY FIREWORKS

HUDSON RIVER, BETWEEN NEW YORK AND NEW JERSEY.

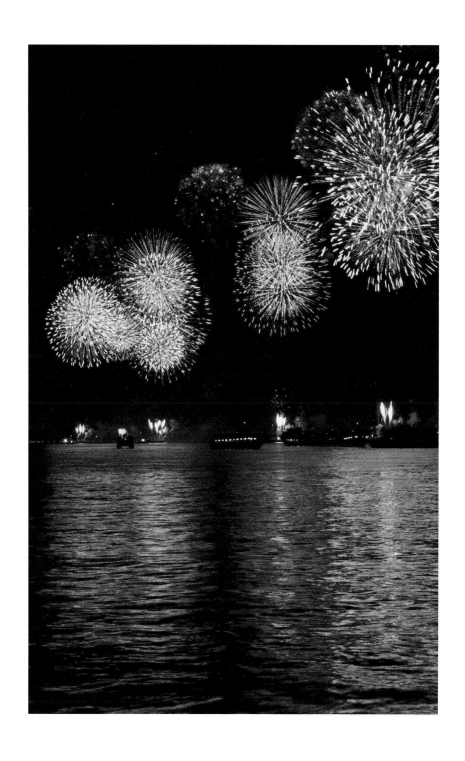

LET THERE BE LIGHT

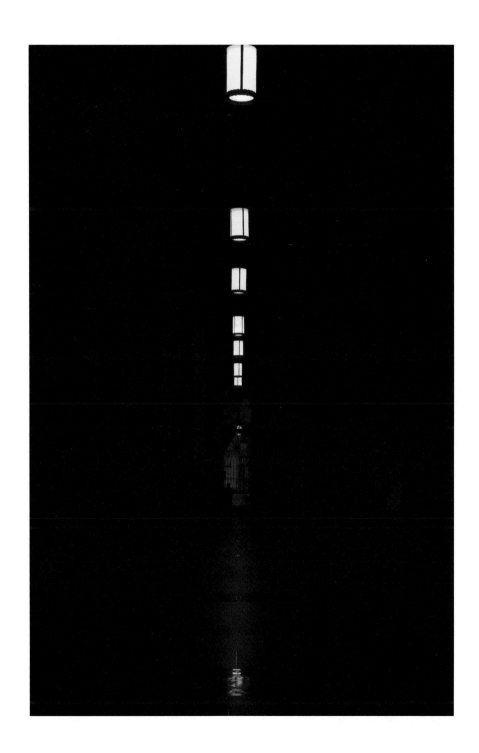

RUSH HOUR

WALL STREET, NEW YORK

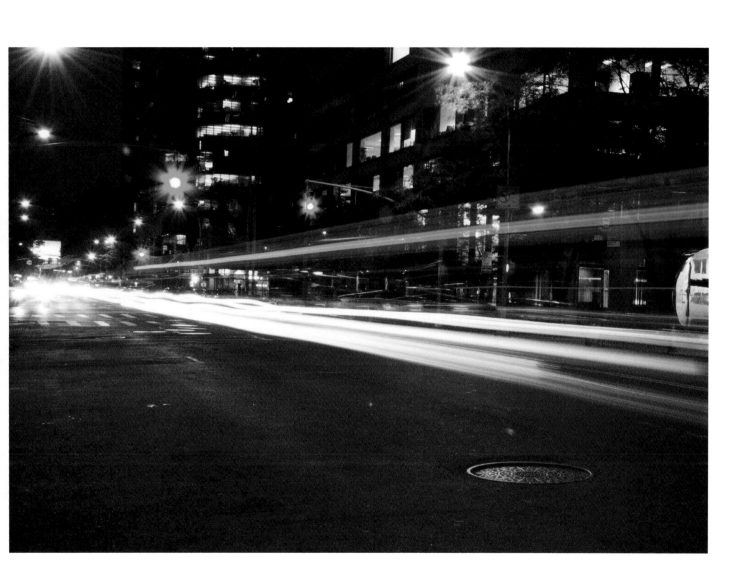

LOTUS TEMPLE

NEW DELHI, INDIA.

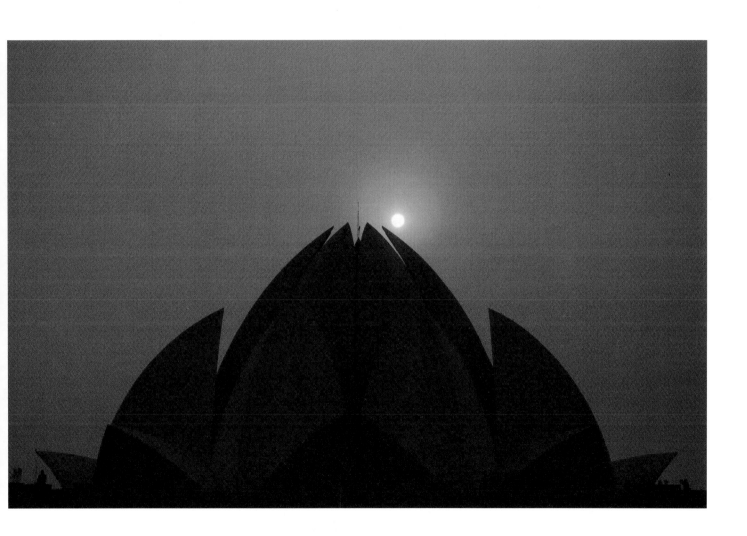

QUTUB MINAR

NEW DELHI, INDIA.

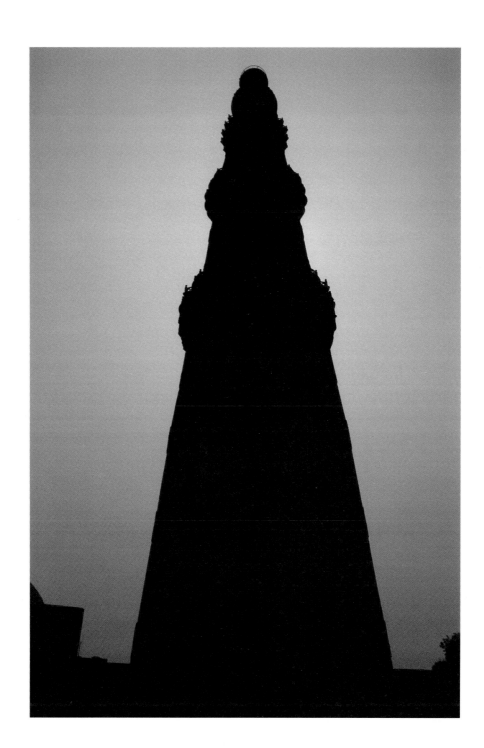

A Walk in the Waters

South Padre Island, Texas.

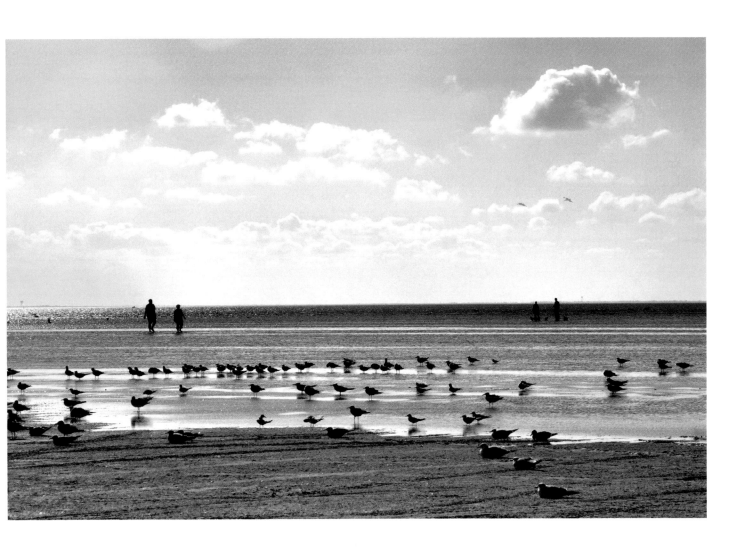

THE ENCHANTED ROCK

Enchanted Rock State Park, Texas.

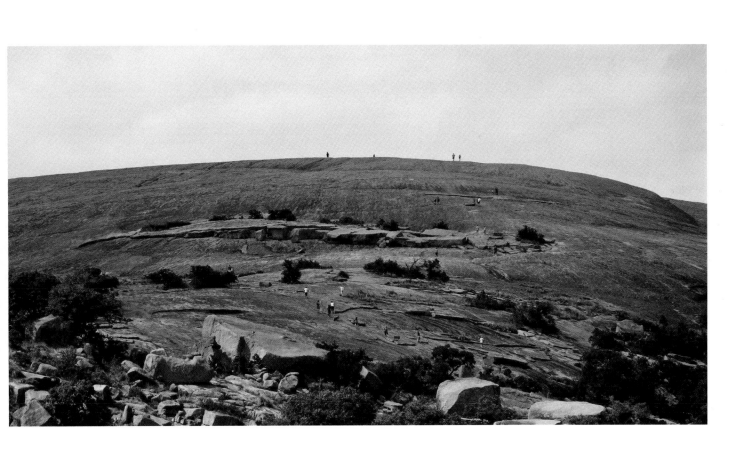

YELLOW CARPET

NEAR MANTHRALAYAM, ANDHRA PRADESH, INDIA.

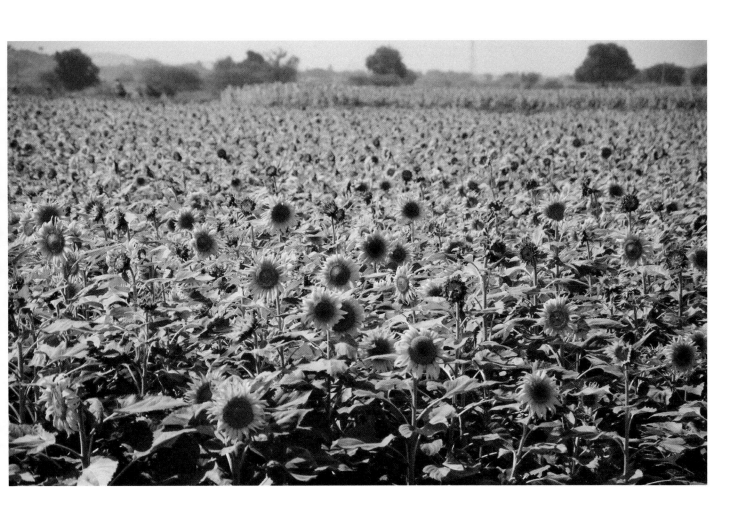

FLUME GORGE

LINCOLN, NEW HAMPSHIRE.

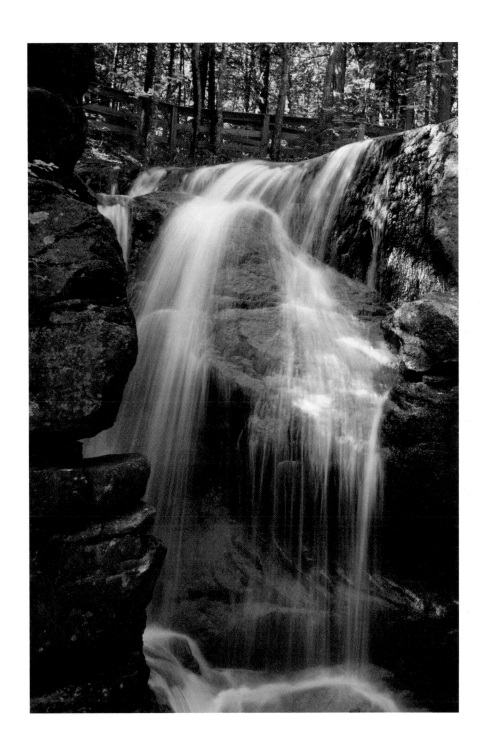

DOWNTOWN REFLECTIONS

CORPUS CHRISTI, TEXAS.

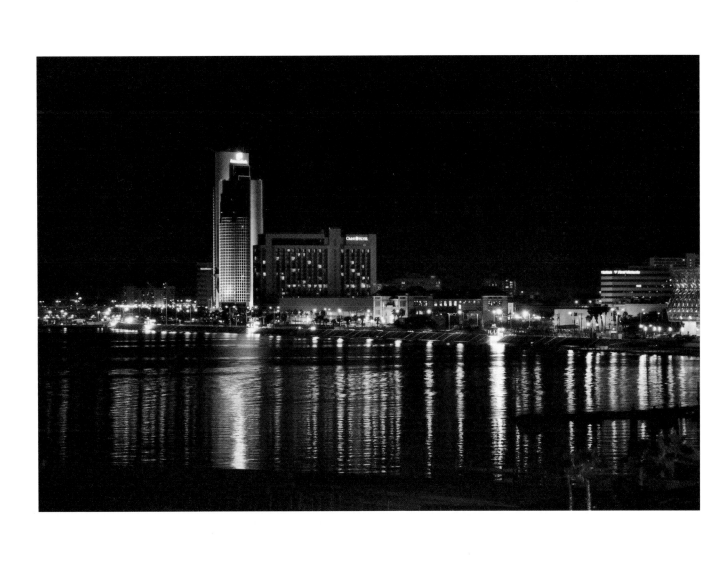

EMPIRE STATE BUILDING AT DUSK

MANHATTAN, NEW YORK.

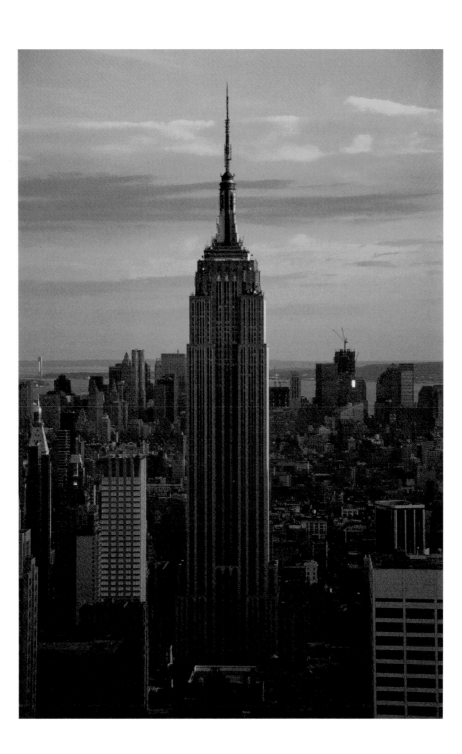

STATUE OF LIBERTY AT SUNSET

BATTERY PARK, NEW YORK.

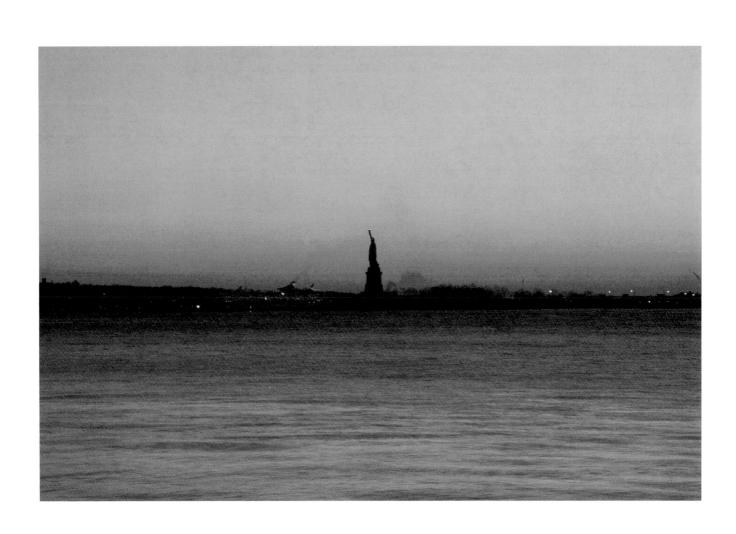

The City That Never Sleeps

Top Of The Rock Observation Deck, New York.

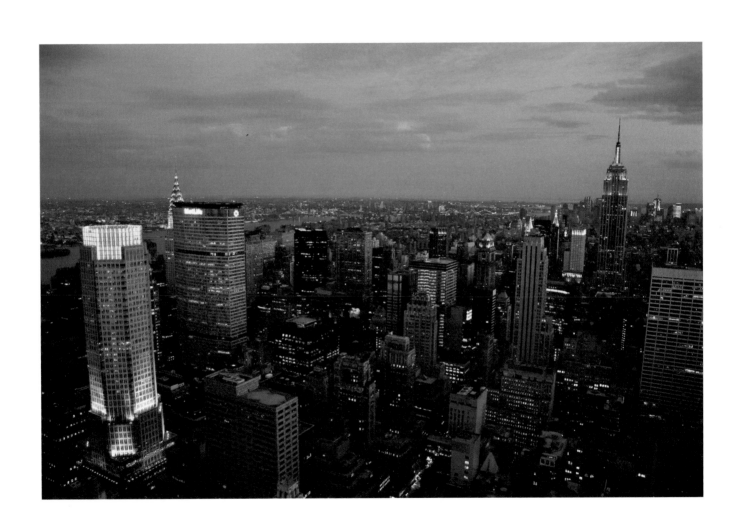